LONDON

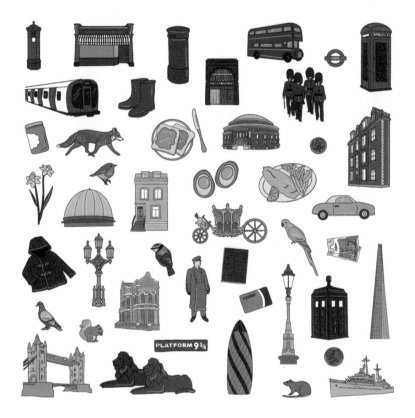

Megan McKean

Smith Street Books

What do you picture when you think of London?
A city famous for its bright red telephone booths and
glossy black taxi cabs — and infamous for its moody
grey skies. The primary red and blue of the London
Underground signage is instantly recognisable, as are
the crimson uniforms of the King's Guard, always tied
to the image of London.

A double-decker bus might not feel nearly as special
if it wasn't for being brilliant red – originally painted
to stand out from competitors, and now a beloved
feature of the city.

As the seasons change so does the city, the leaves
in Hyde Park shifting to oranges and ambers in
autumn, while the pastel buildings of Notting Hill
are complemented perfectly by the wisteria blooming
in spring. Once you start to notice the tints and tones
of your surroundings, you can't help but build your
own rainbow as you move through the city.

Red pillar post boxes, orange brick buildings,
yellow daffodils, green cucumbers at tea time,
the blue on the £5 note, or the pink magnolias
in season – all making up the vibrant
spectrum that is London.

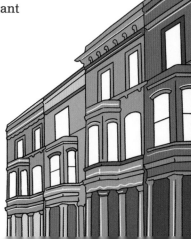

Pillar post boxes
Wembley Stadium
Wellington boots
London Underground
Double-decker buses
Telephone booths
King's Guard
Beefeaters

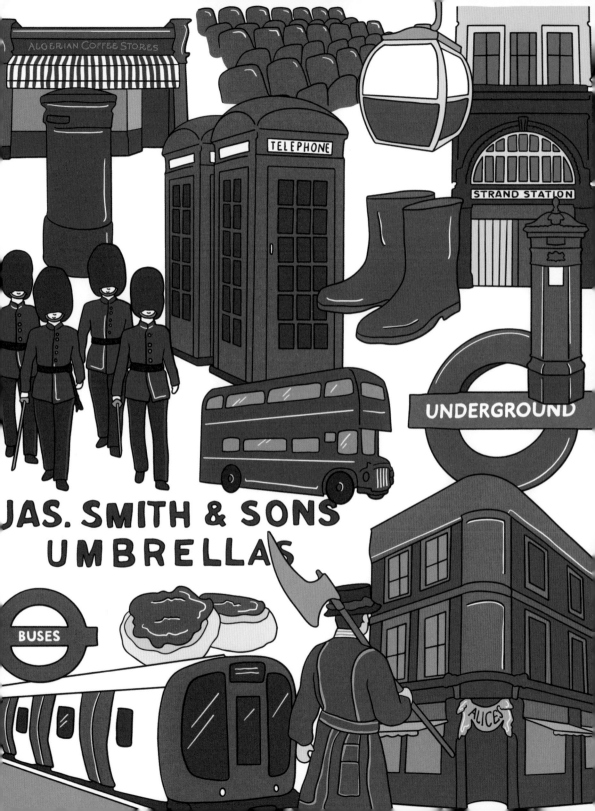

Thin House
V&A Museum
Autumn leaves
Royal Albert Hall
London Overground
St Pancras Station
Marmalade
Foxes

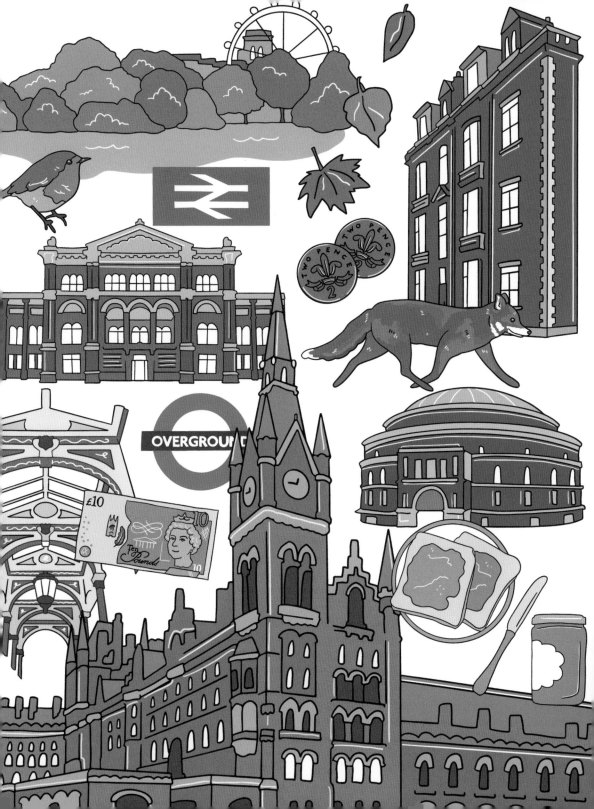

Big Ben
Blue tits
Gold State Coach
Grosvenor Prints
Van Gogh's *Sunflowers*
Fish and chips
Circle line
Daffodils

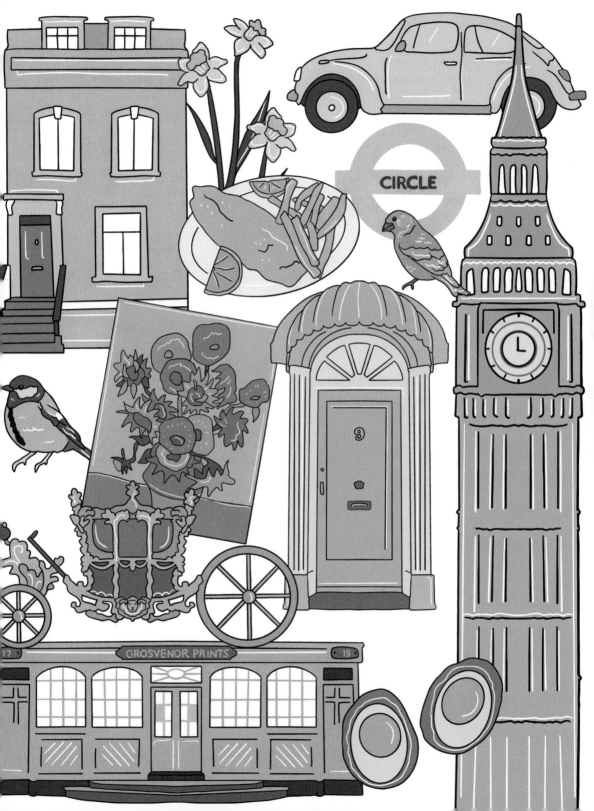

CIRCLE

GROSVENOR PRINTS

17

19

9

Lina Stores

Borough Market

Madame Tussauds

Waterloo & City line

Cucumber sandwiches

Westminster Bridge

Cabmen's Shelters

District line

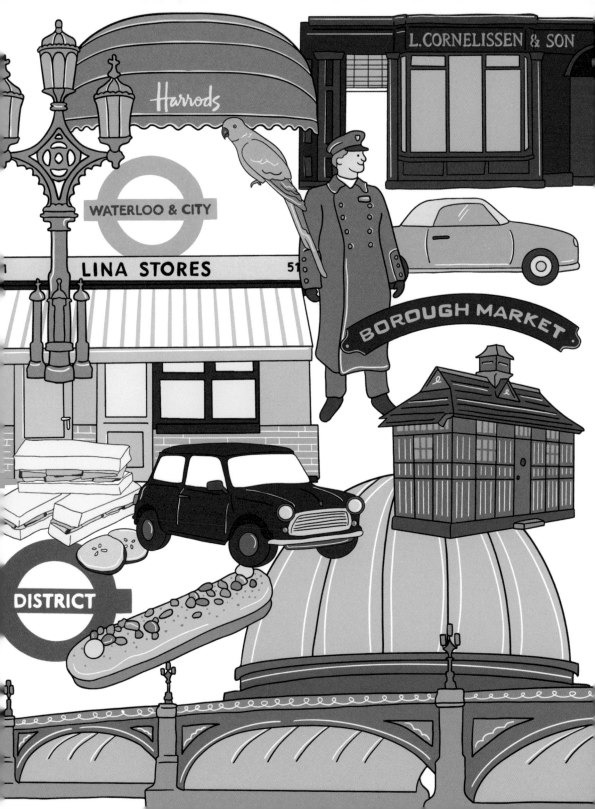

The Shard
Tower Bridge
Piccadilly line
Earl's Court police box
Yves Klein's *IKB 79*
Oyster cards
Duffle coats
Tulip Stairs

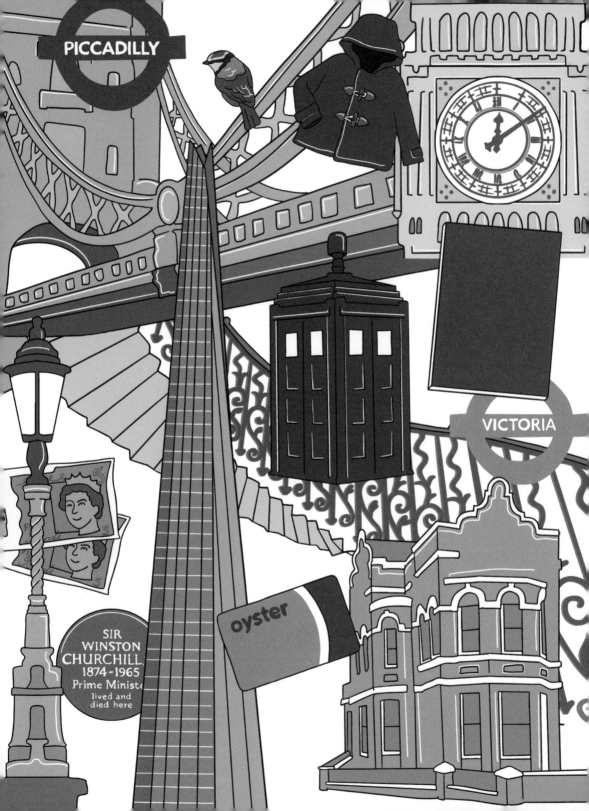

The Gherkin
HMS Belfast
London Stone
20 Fenchurch Street
Millennium Bridge
Landseer Lions
Platform 9¾
Pigeons

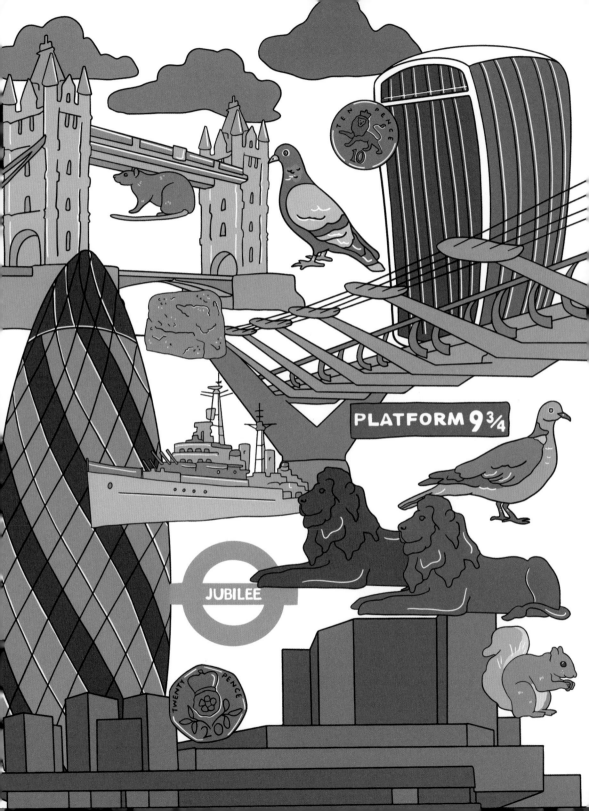

Harrods
Tate Modern
Sherlock's cap
Brick Lane bagels
Westminster Abbey
Shoreditch buildings
Bakerloo line
Sparrows

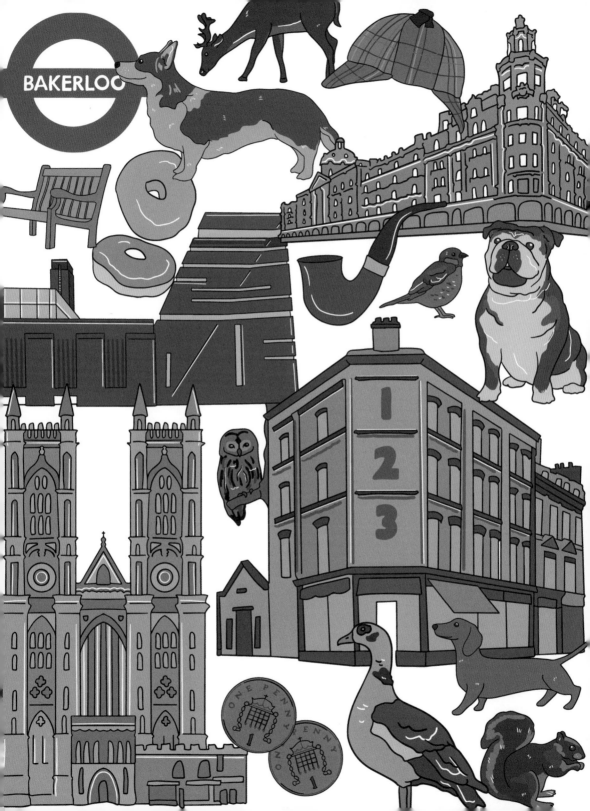

BAKERLOO

White Tower
British Museum
Swans in Hyde Park
Pelicans in St James's Park
Dippy the dinosaur
Buckingham Palace
Globe Theatre
Cream tea

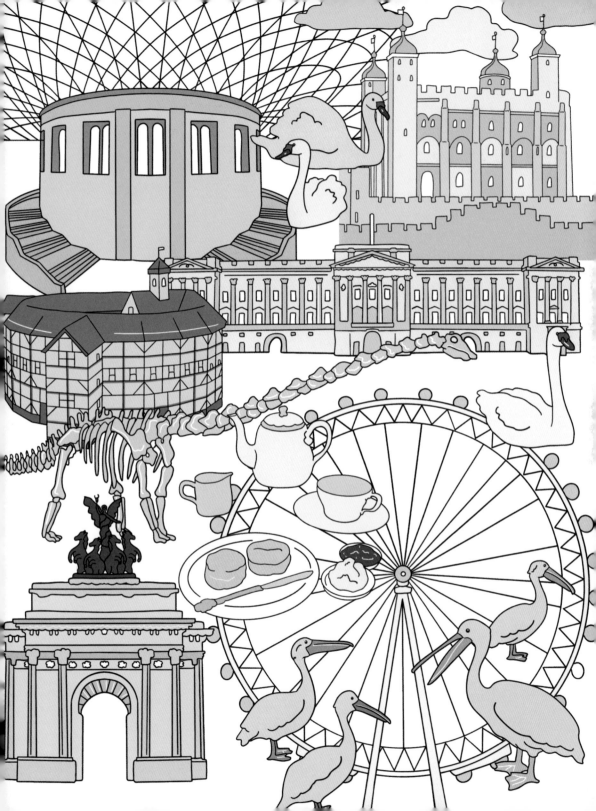

Magnolias
Chelsea terraces
Pottery Lane house
Queen Mary's roses
Hammersmith & City line
Lola le Pink Figaro
Peggy Porschen
EL&N cafes

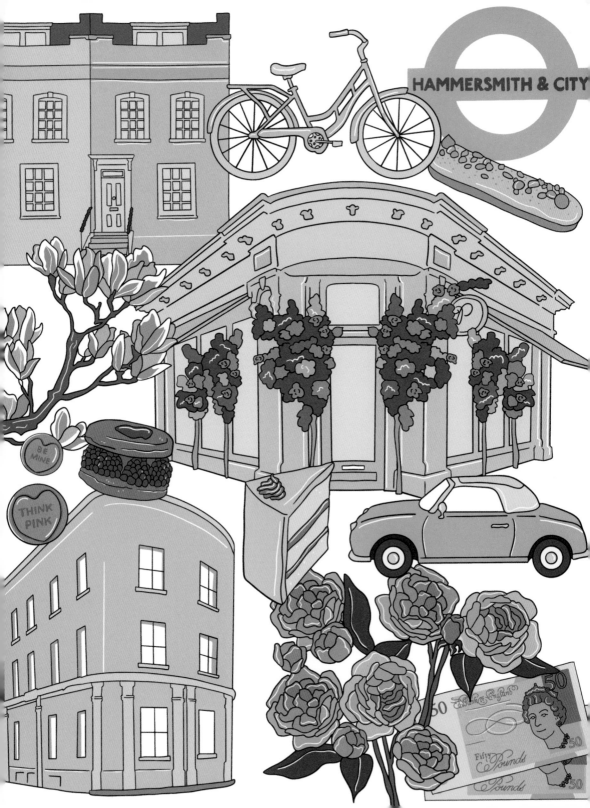

HAMMERSMITH & CITY

London

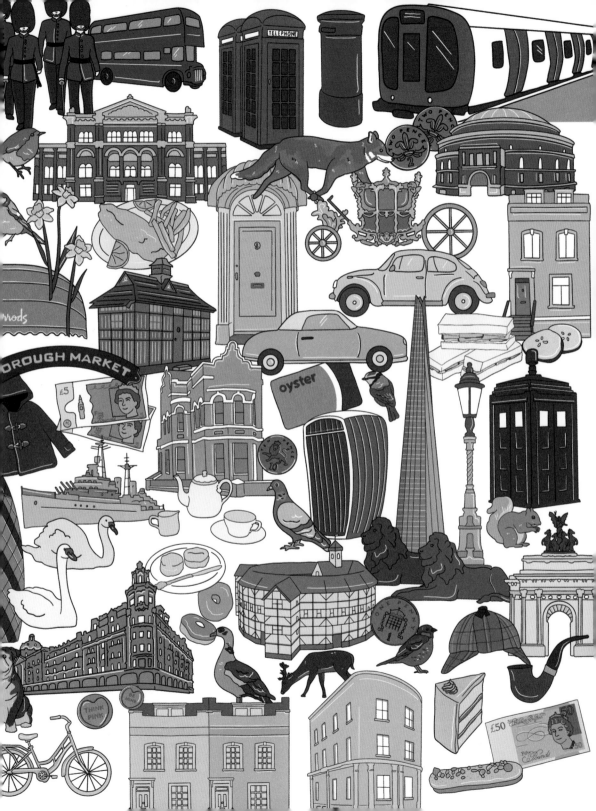

Smith Street Books

Published in 2023 by Smith Street Books
Naarm (Melbourne) | Australia
smithstreetbooks.com

ISBN: 978-1-9227-5-450-9 (US) / 978-1-9227-5477-6 (AU & UK)

Smith Street Books respectfully acknowledges the
Wurundjeri People of the Kulin Nation, who are the
Traditional Owners of the land on which we work,
and we pay our respects to their Elders past and present.

Publisher: Paul McNally
Senior Editor: Hannah Koelmeyer
Design layout: Megan McKean
Proofreader: Rosanna Dutson

Printed & bound in China by C&C Offset Printing Co., Ltd.

Book 276
10 9 8 7 6 5 4 3 2 1

MIX
Paper | Supporting
responsible forestry
FSC® C008047

For Joshua